T-REX TRYING

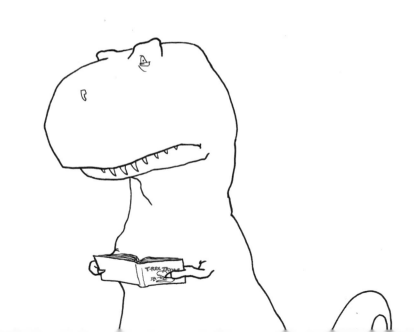

T-REX TRYING

THE UNFORTUNATE TRIALS OF THE TYRANT LIZARD KING

HUGH MURPHY

MICHAEL JOSEPH
an imprint of
PENGUIN BOOKS

MICHAEL JOSEPH

Published by the Penguin Group

Penguin Books Ltd, 80 Strand, London WC2R 0RL, England

Penguin Group (USA) Inc., 375 Hudson Street, New York,
New York 10014, USA

Penguin Group (Canada), 90 Eglinton Avenue East,
Suite 700, Toronto, Ontario, Canada M4P 2Y3
(a division of Pearson Penguin Canada Inc.)

Penguin Ireland, 25 St Stephen's Green, Dublin 2, Ireland
(a division of Penguin Books Ltd)

Penguin Group (Australia), 250 Camberwell Road,
Camberwell, Victoria 3124, Australia
(a division of Pearson Australia Group Pty Ltd)

Penguin Books India Pvt Ltd, 11 Community Centre,
Panchsheel Park, New Delhi – 110 017, India

Penguin Group (NZ), 67 Apollo Drive, Rosedale,
Auckland 0632, New Zealand
(a division of Pearson New Zealand Ltd)

Penguin Books (South Africa) (Pty) Ltd, Block D, Rosebank
Office Park, 181 Jan Smuts Avenue, Parktown North,
Gauteng 2193, South Africa

Penguin Books Ltd, Registered Offices: 80 Strand, London
WC2R 0RL, England

www.penguin.com

First published 2012
001

Copyright © Hugh Murphy, 2012

The moral right of the author has been asserted

Set in Din and Strangelove Text

Colour reproduction by Altaimage Ltd
Printed in Italy by Graphicom

A CIP catalogue record for this book is available from the
British Library

ISBN: 978-0-718-17712-6

ALWAYS LEARNING **PEARSON**

For Sarah – the brightest, best, most beautiful person in my life

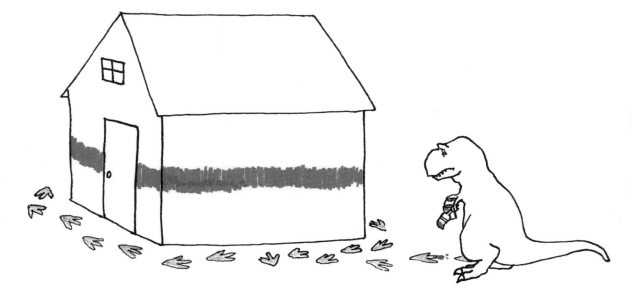

T-Rex trying to paint his house . . .

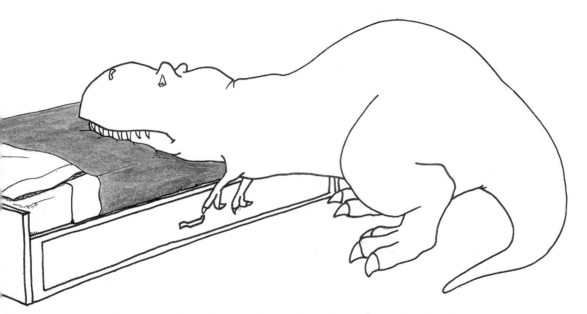

T-Rex trying to pull out a trundle bed. . .

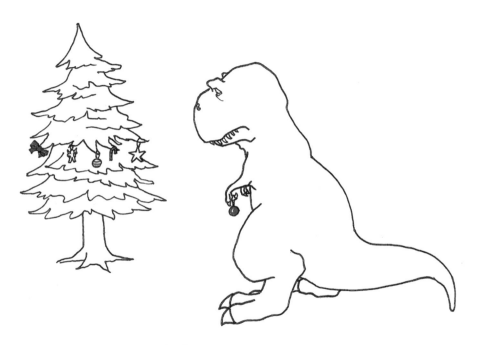

T-Rex trying to hang X-mas ornaments...

T-Rex trying to pick flowers . . .

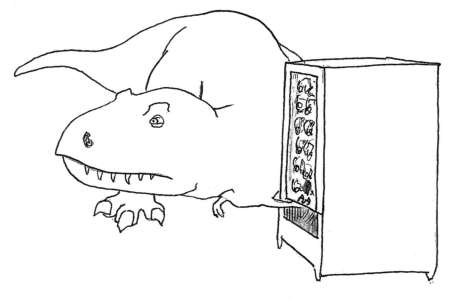

T-Rex trying to steal from a
vending machine...

T-Rex trying to make snow angels...

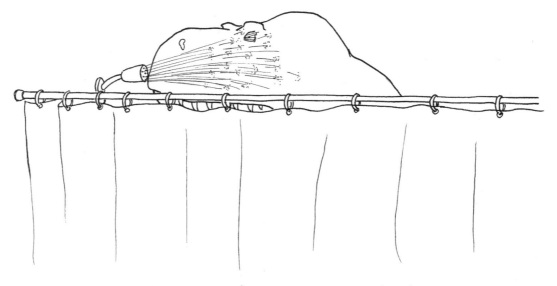

T-Rex trying to adjust the shower head. . .

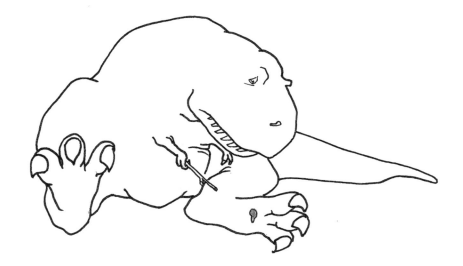

T-Rex trying to get gum off the bottom of his foot...

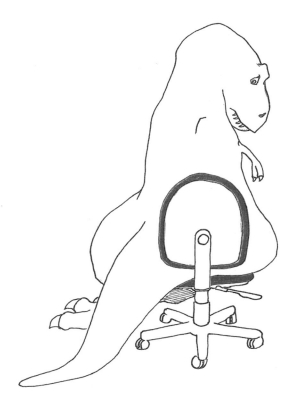

T-Rex trying to adjust his office chair...

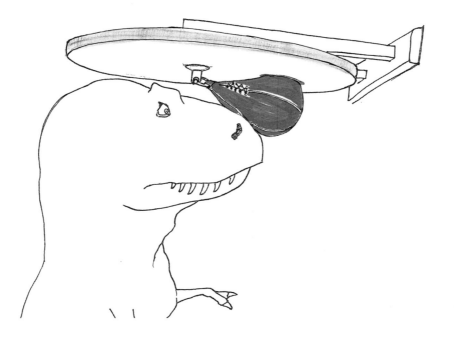

T-Rex trying to use the speed bag...

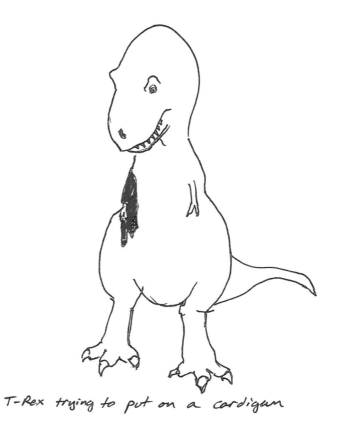

T-Rex trying to put on a cardigan

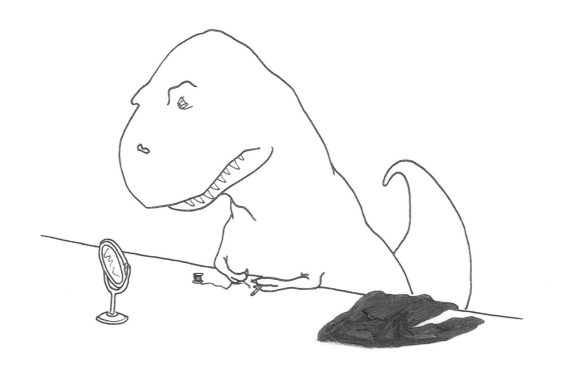

T-Rex trying to make some alterations to his cardigan . . .

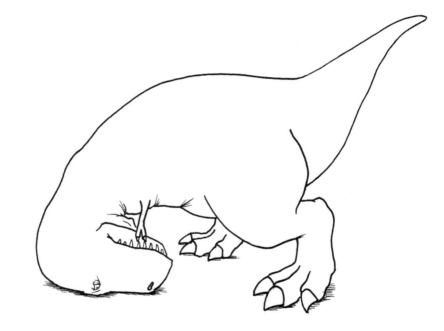

T-Rex trying to do a cartwheel...

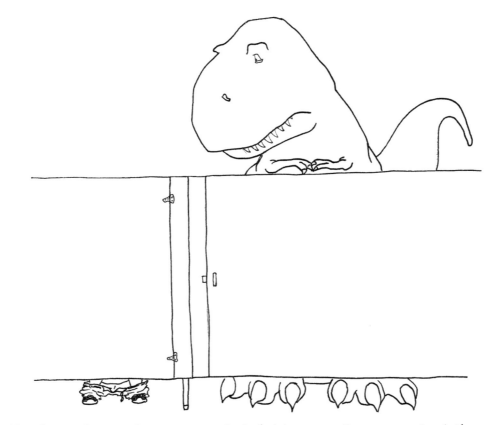

T-Rex trying to ask for a new roll of toilet paper from the next stall . . .

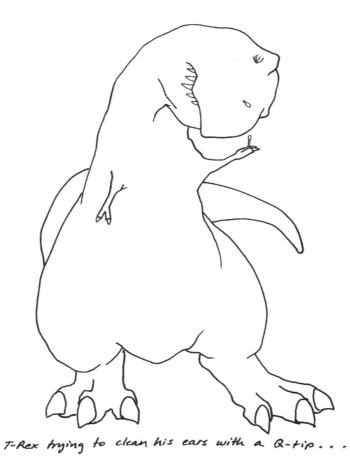

T-Rex trying to clean his ears with a Q-tip . . .

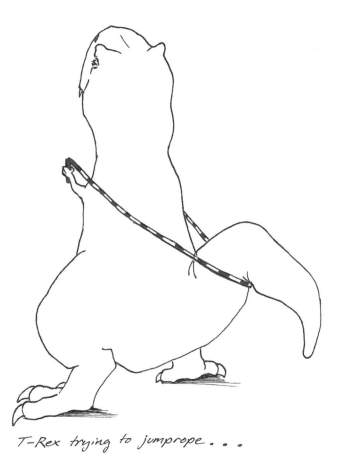

T-Rex trying to jumprope . . .

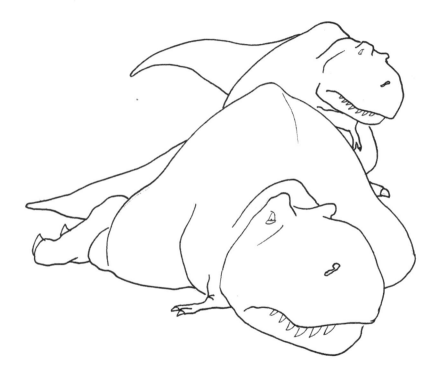

T-Rex trying to compete in a wheelbarrow race . . .

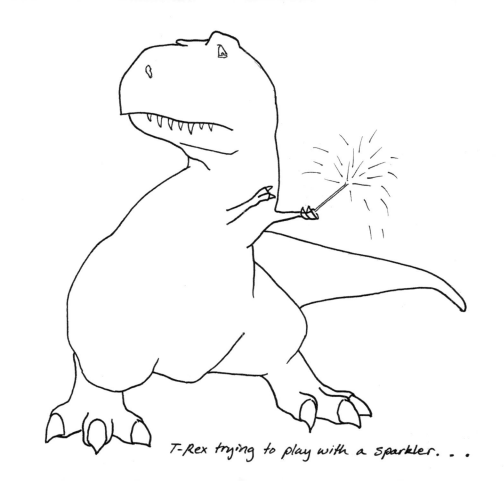

T-Rex trying to play with a sparkler. . .

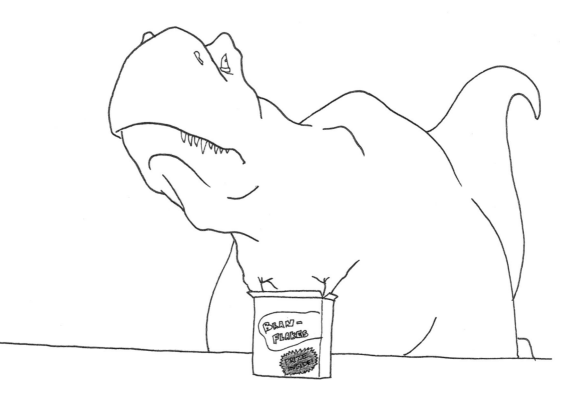

T-Rex trying to get the prize out of a cereal box...

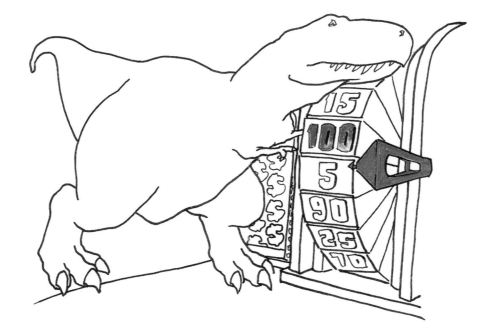

T-Rex trying to spin the wheel on The Price is Right...

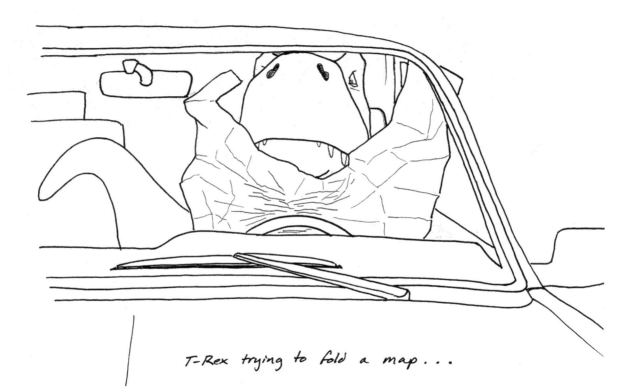

T-Rex trying to fold a map...

12 FT

T-Rex trying to use Water Wings . . .

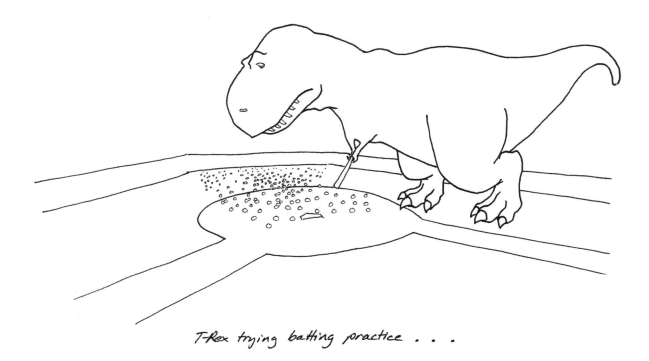

T-Rex trying batting practice . . .

T-Rex trying to start a curling team...

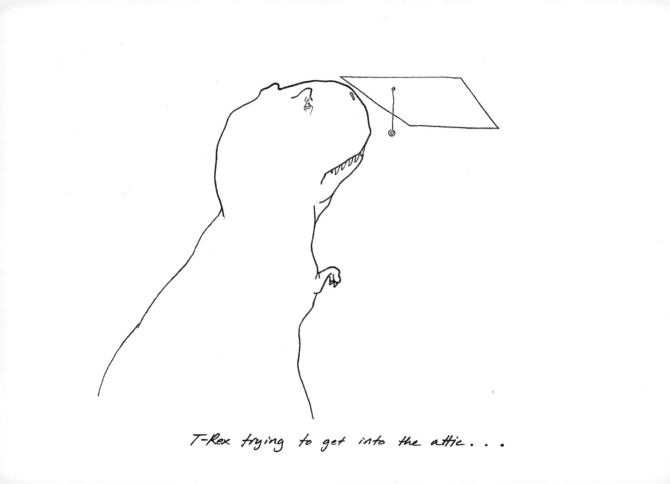

T-Rex trying to get into the attic . . .

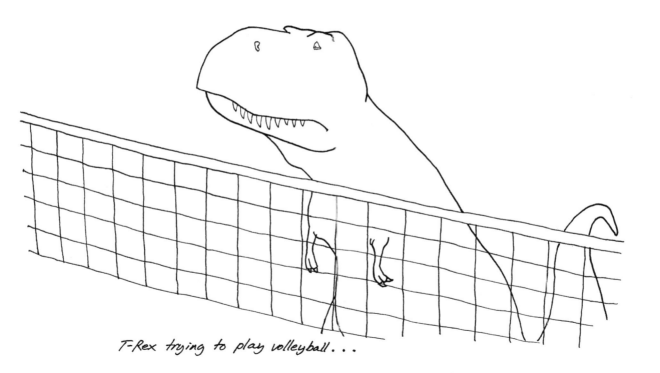

T-Rex trying to play volleyball...

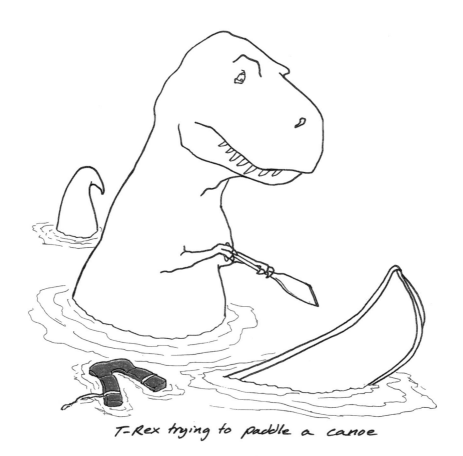

T-Rex trying to paddle a canoe

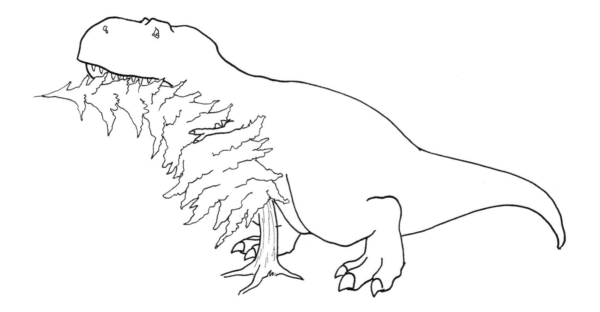

T-Rex trying to climb a tree . . .

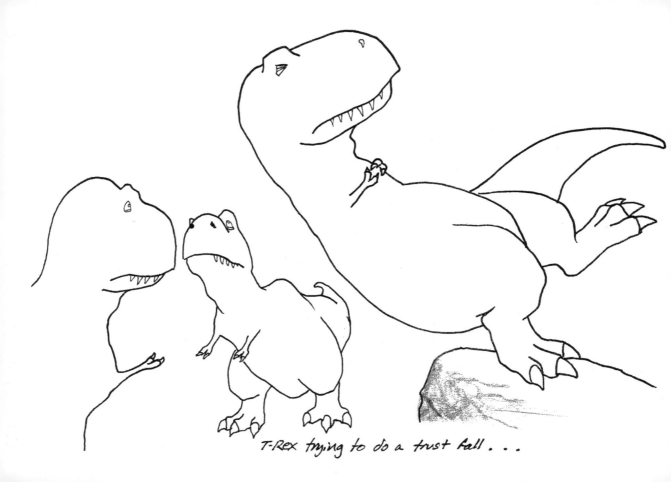

T-Rex trying to do a trust fall . . .

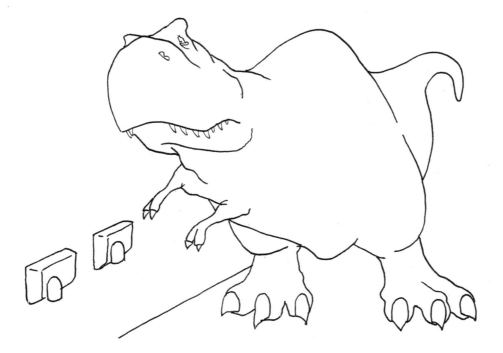

T-Rex trying to use a hand dryer in a public restroom...

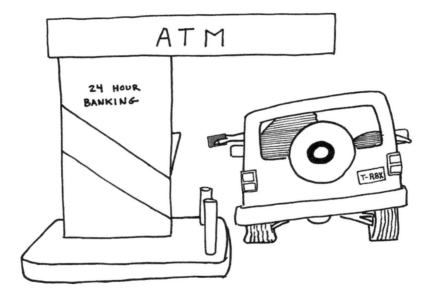

ATM

24 HOUR
BANKING

T-R8X

T-Rex trying to use a drive thru ATM...

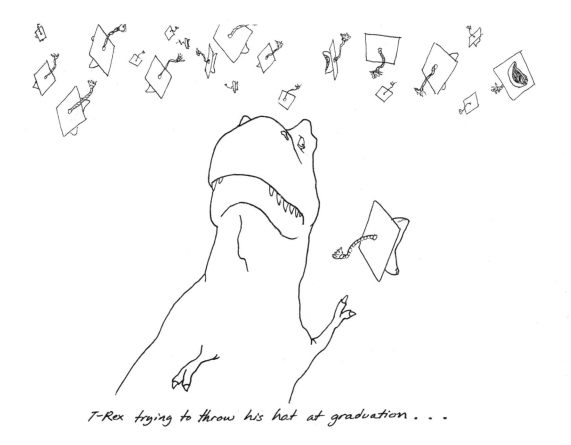

T-Rex trying to throw his hat at graduation . . .

T-Rex trying downward-dog...

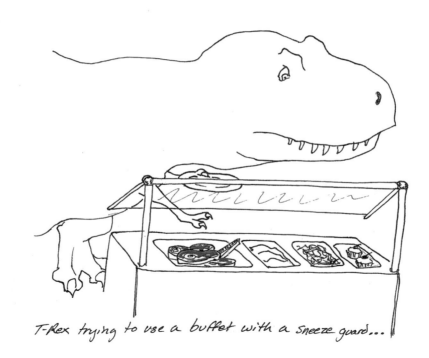

T-Rex trying to use a buffet with a sneeze guard...

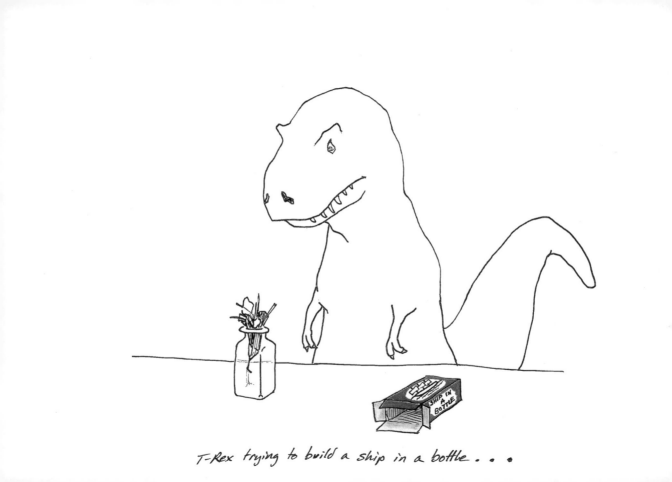

T-Rex trying to build a ship in a bottle . . .

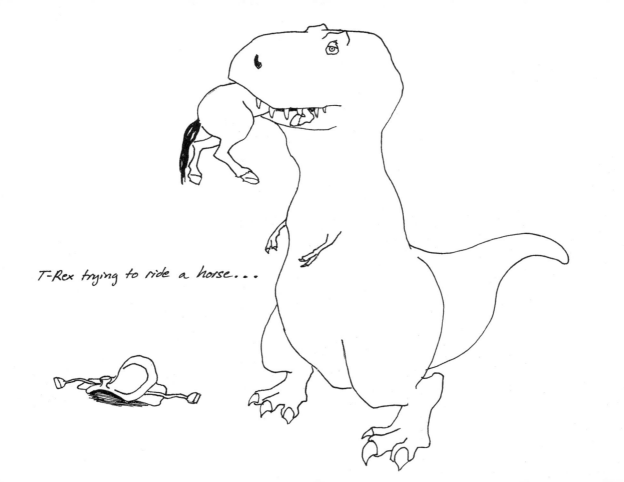

T-Rex trying to ride a horse...

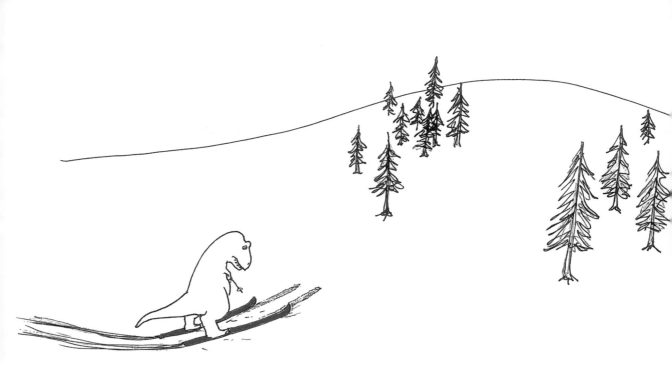

T-Rex trying to cross-country ski . . .

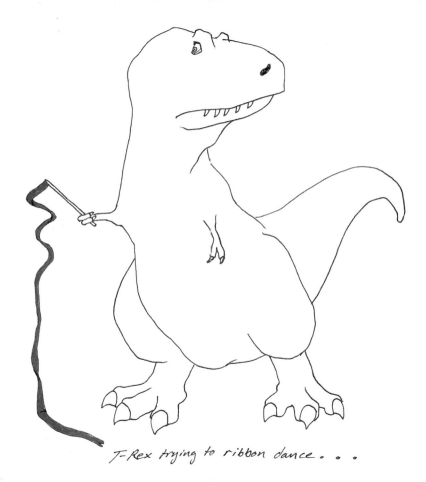

T-Rex trying to ribbon dance. . .

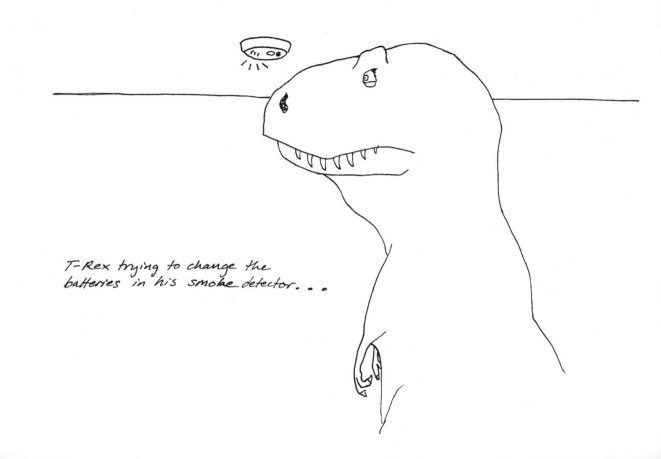

T-Rex trying to change the
batteries in his smoke detector...

T-Rex trying to play rock - paper - scissors ...

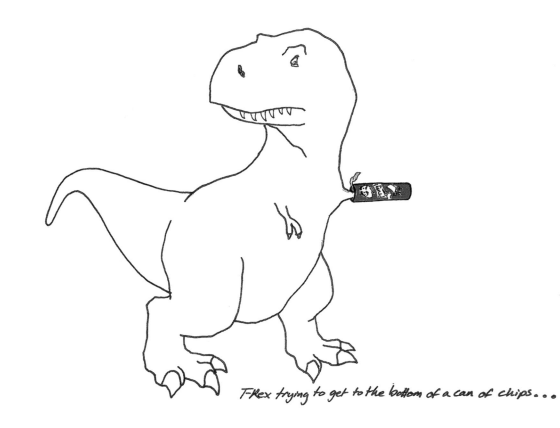

T-Rex trying to get to the bottom of a can of chips...

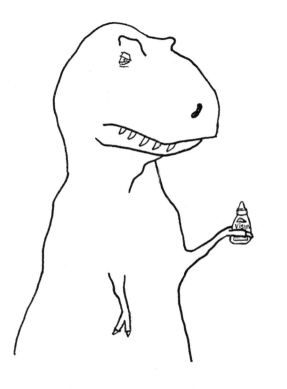

T-Rex trying to use eye drops . . .

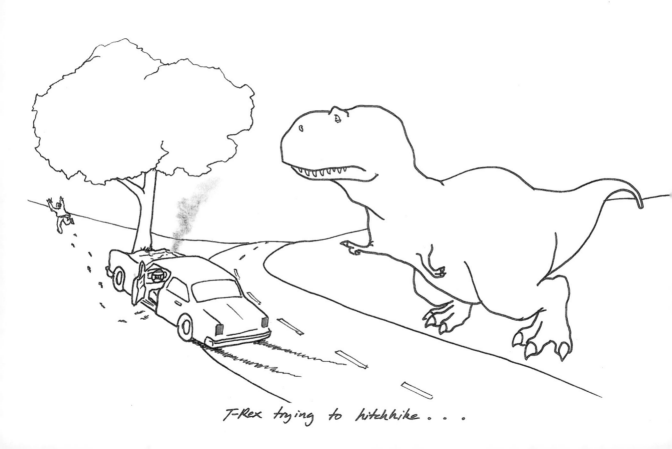

T-Rex trying to hitchhike . . .

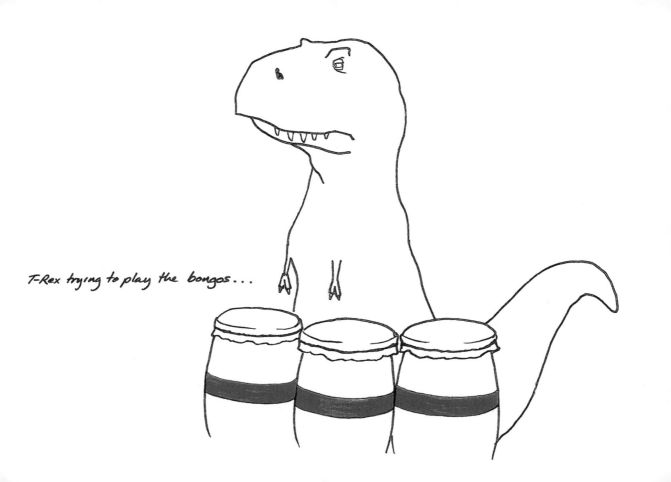

T-Rex trying to play the bongos...

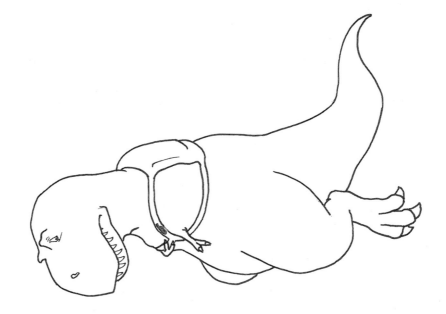

T-Rex trying to pull the ripcord on his parachute

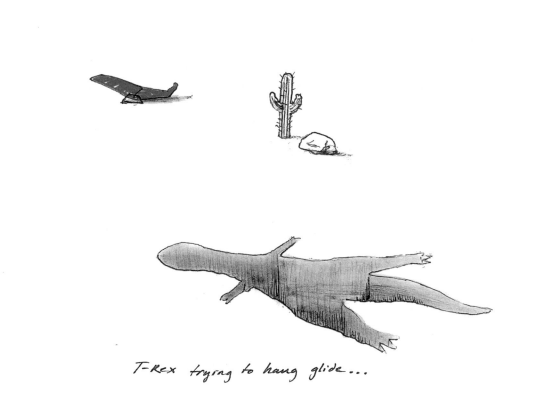

T-Rex trying to hang glide...

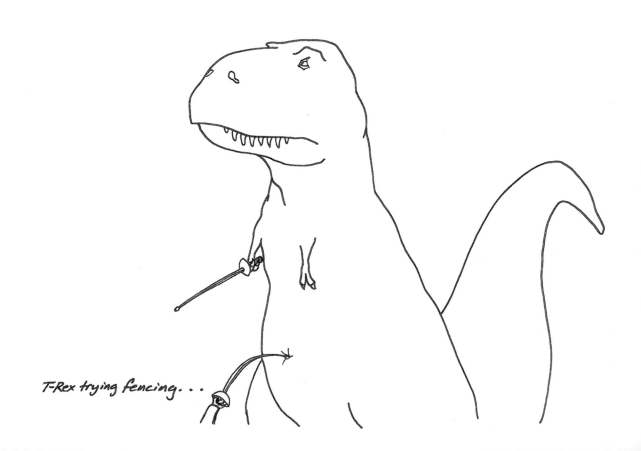

T-Rex trying fencing. . .

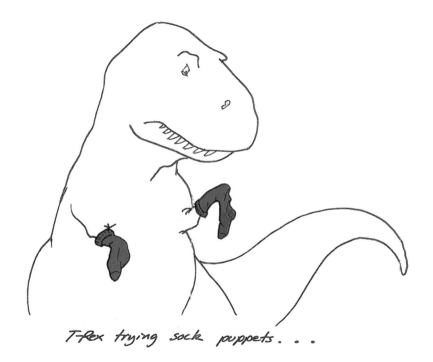

T-Rex trying sock puppets . . .

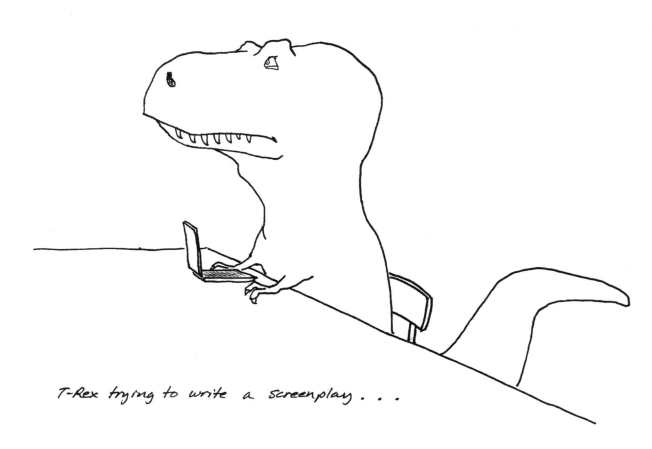

T-Rex trying to write a screenplay . . .

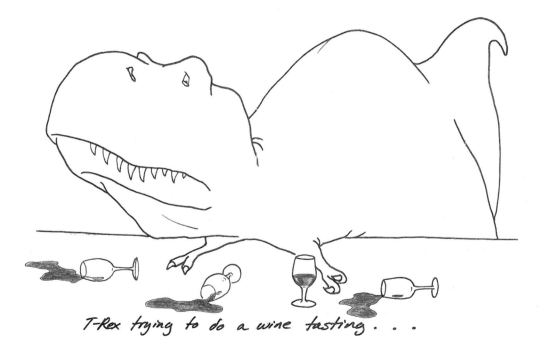

T-Rex trying to do a wine tasting . . .

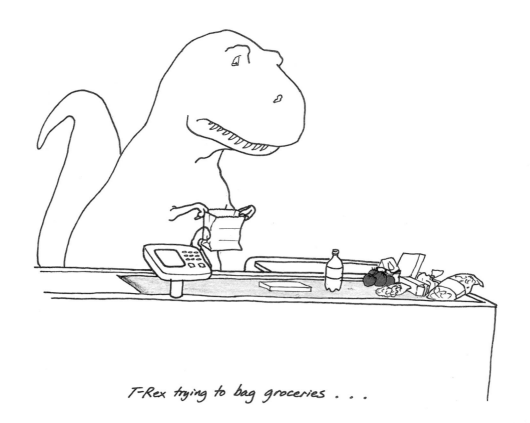

T-Rex trying to bag groceries . . .

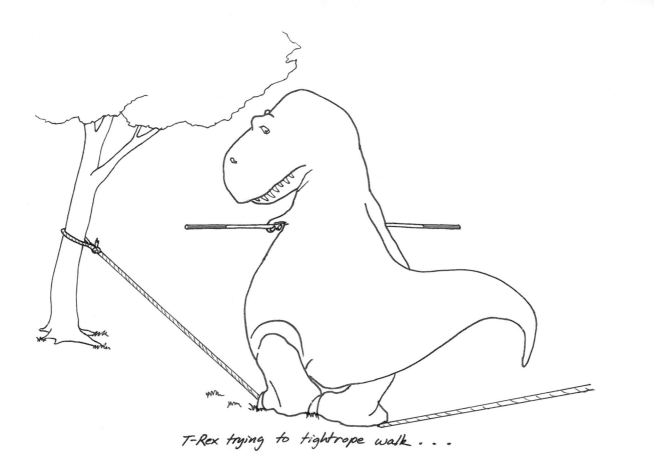

T-Rex trying to tightrope walk . . .

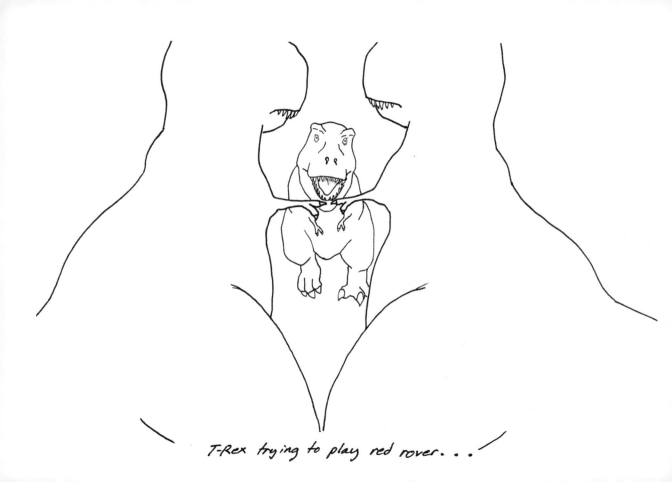

T-Rex trying to play red rover...

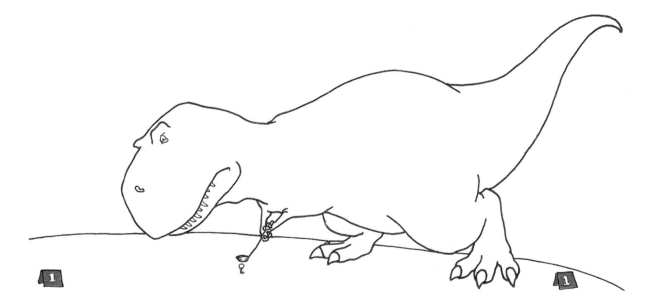

T-Rex trying to play a round of golf. . .

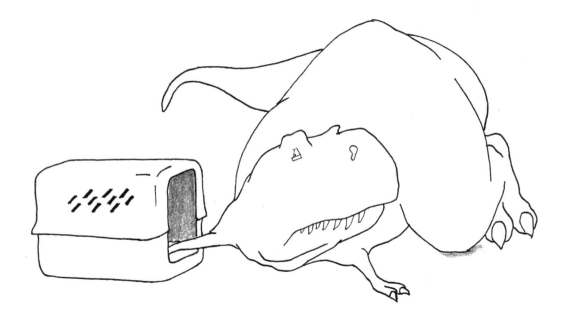

T-Rex trying to clean the litter box . . .

T-Rex trying to sing head, shoulders, knees and toes . . .

T-Rex trying to make balloon animals...

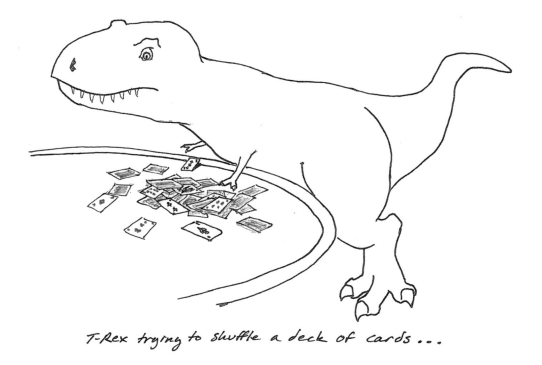

T-Rex trying to shuffle a deck of cards...

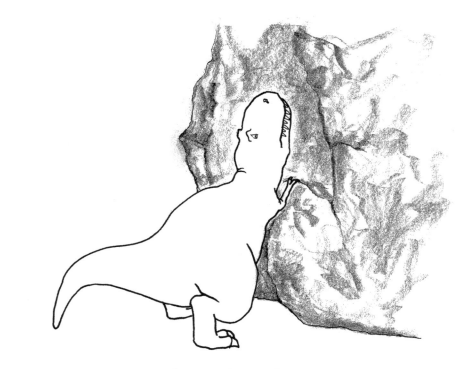

T-Rex trying to rock climb . . .

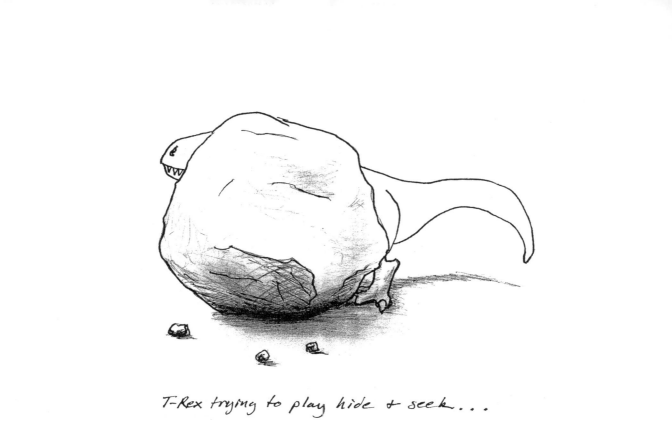

T-Rex trying to play hide & seek...

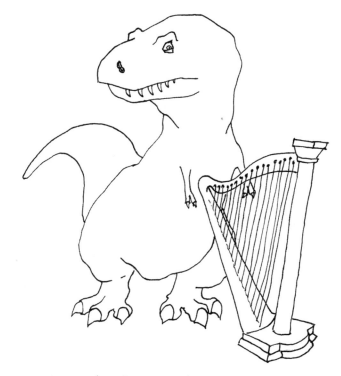

T-Rex trying to play the harp...

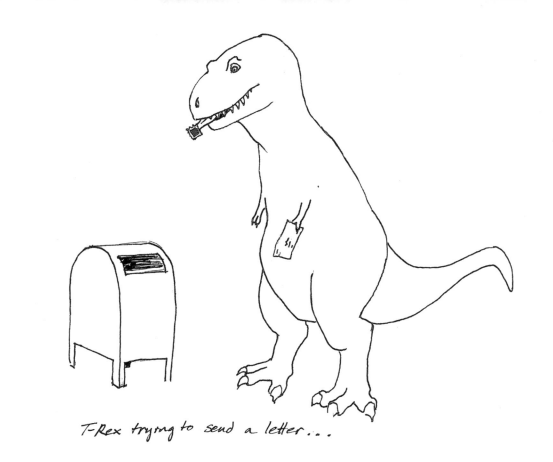

T-Rex trying to send a letter...

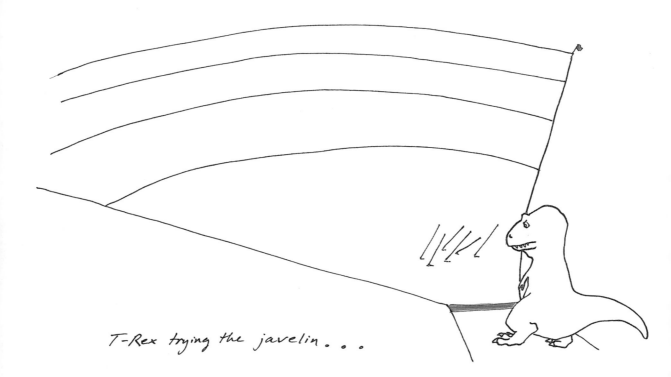

T-Rex trying the javelin. . .

T-Rex trying to change a light bulb...

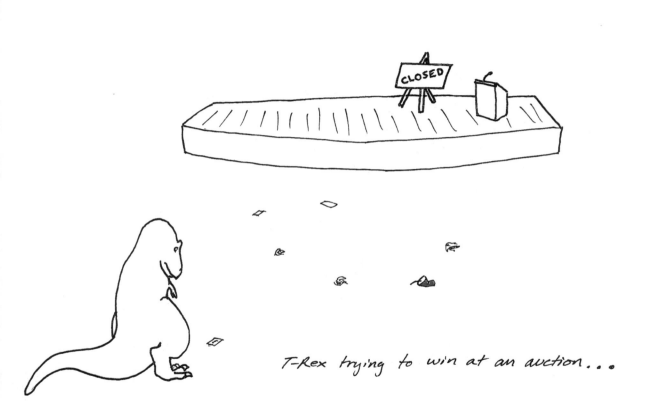

T-Rex trying to win at an auction...

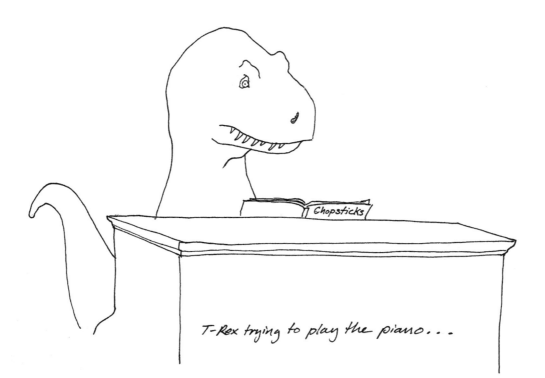

T-Rex trying to play the piano...

T-Rex trying to play tetherball...

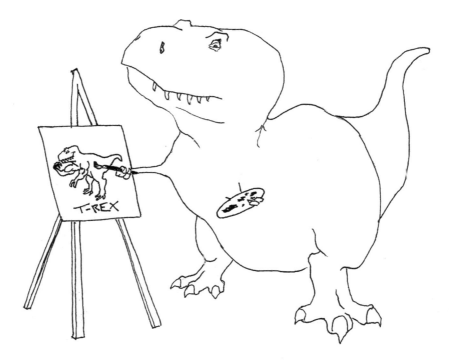

T-Rex trying to paint a self-portrait...

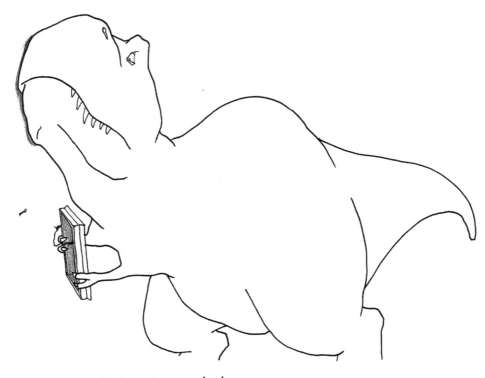

T-Rex trying to hang a painting . . .

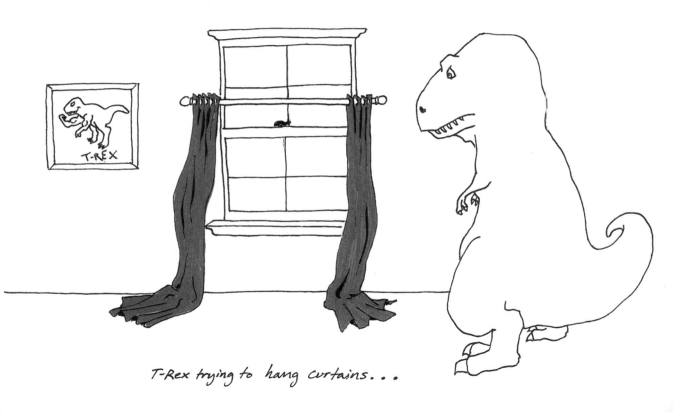

T-Rex trying to hang curtains...

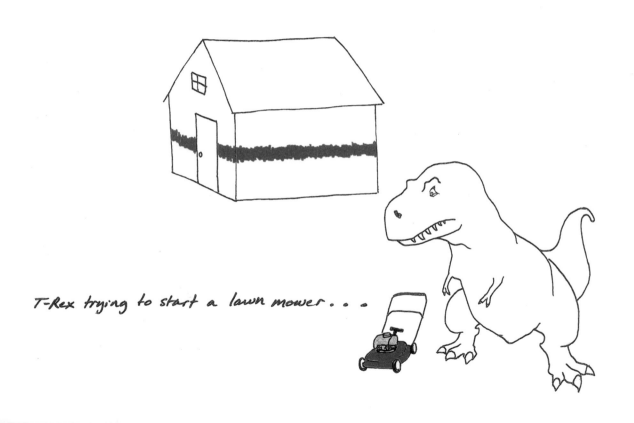

T-Rex trying to start a lawn mower . . .

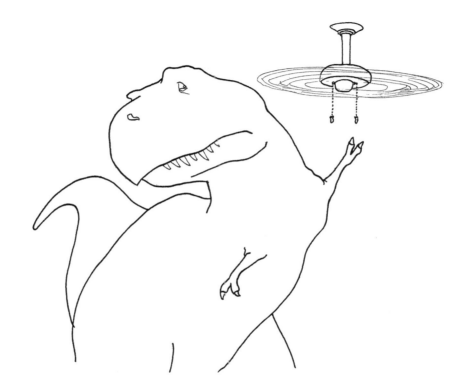

T-Rex trying to turn off a ceiling fan . . .

T-Rex trying to brush his teeth...

T-Rex trying to floss...

T-Rex trying to play water polo . . .

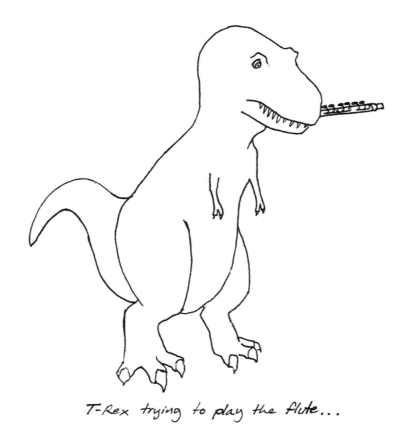

T-Rex trying to play the flute...

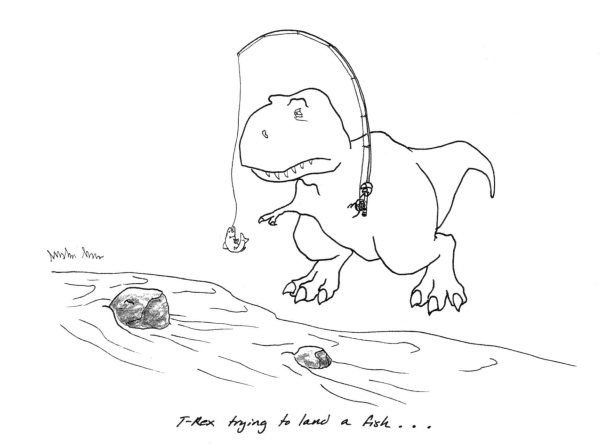

T-Rex trying to land a fish . . .

T-Rex trying to brag about the fish he caught...

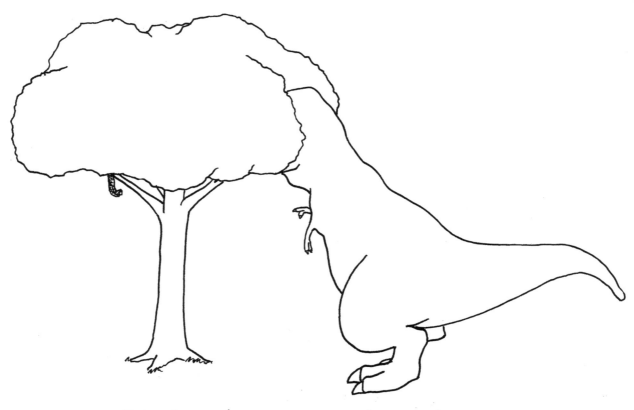

T-Rex trying to rescue a cat from a tree . . .

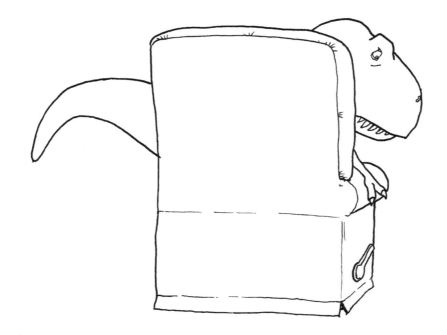

T-Rex trying to recline his La-Z-Boy . . .

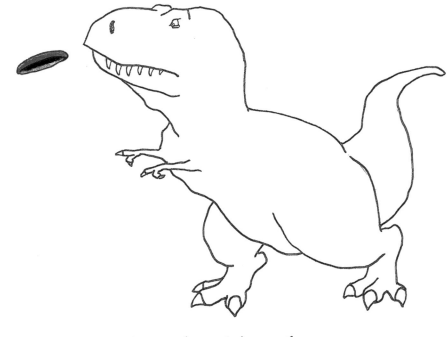

T-Rex trying to catch a frisbee . . .

T-Rex trying to clean his gutters . . .

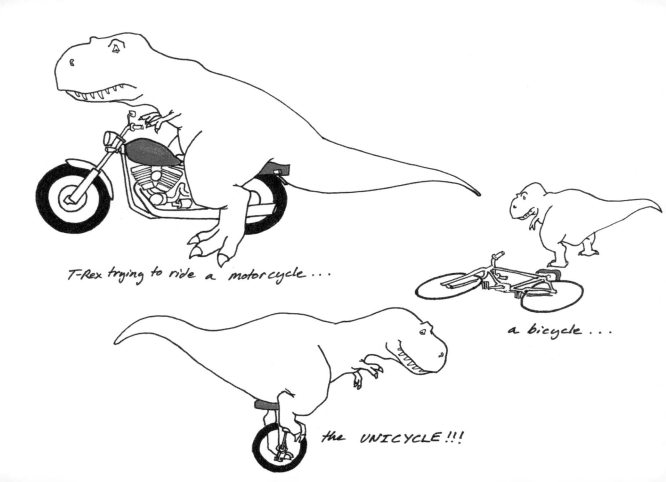

T-Rex trying to ride a motorcycle . . .

a bicycle . . .

the UNICYCLE !!!

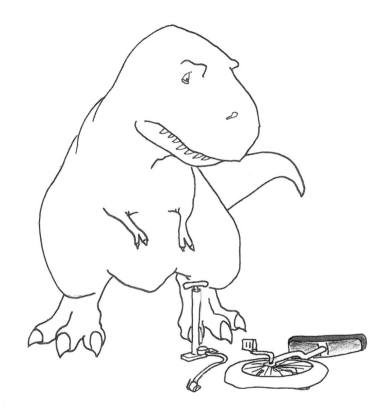

T-Rex trying to pump up the tire on his unicycle . . .

T-Rex trying to take up photography . . .

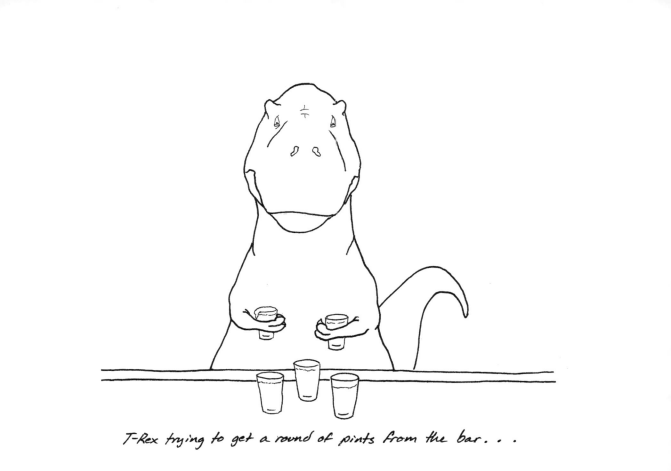

T-Rex trying to get a round of pints from the bar . . .

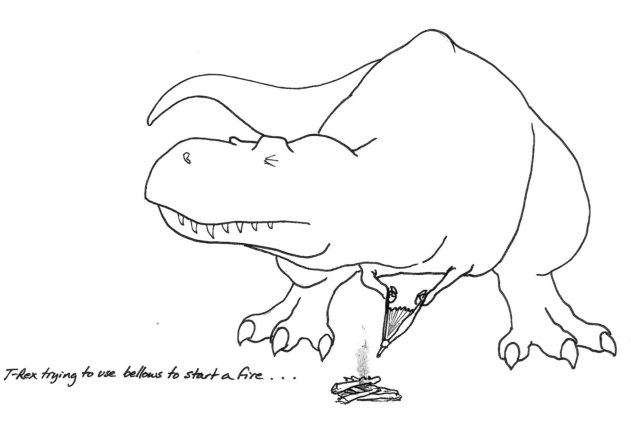

T-Rex trying to use bellows to start a fire . . .

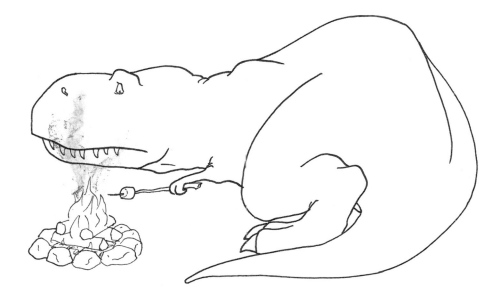

T-Rex trying to roast a marshmallow . . .

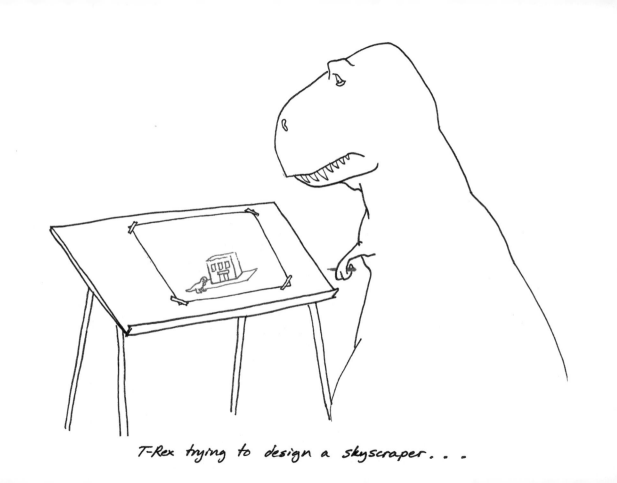

T-Rex trying to design a skyscraper...

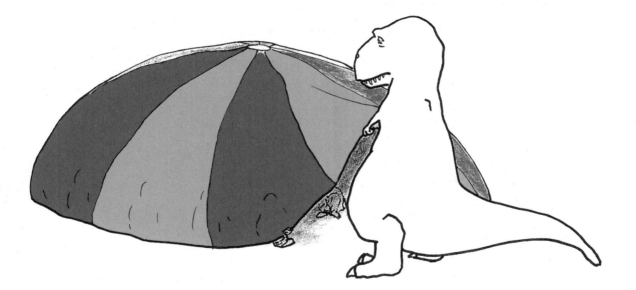

T-Rex trying to play the parachute game. . .

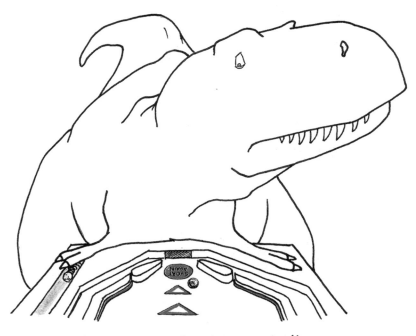

T-Rex trying to play pinball . . .

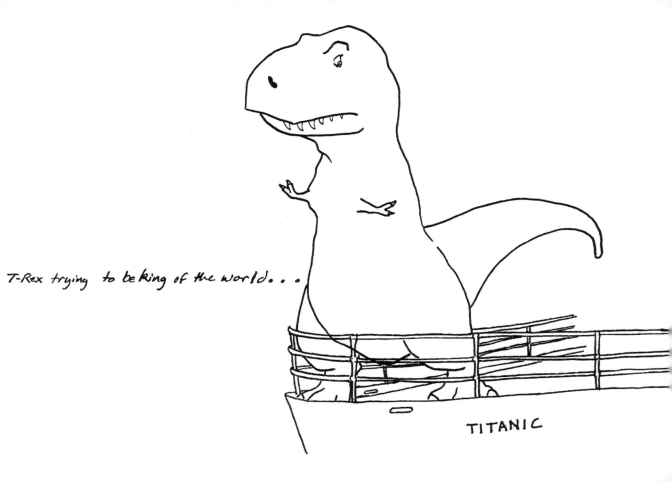

T-Rex trying to be king of the world...

TITANIC

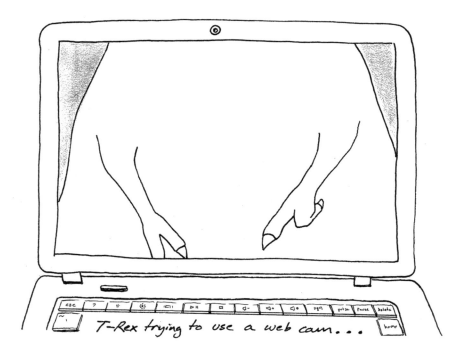

T-Rex trying to use a web cam...

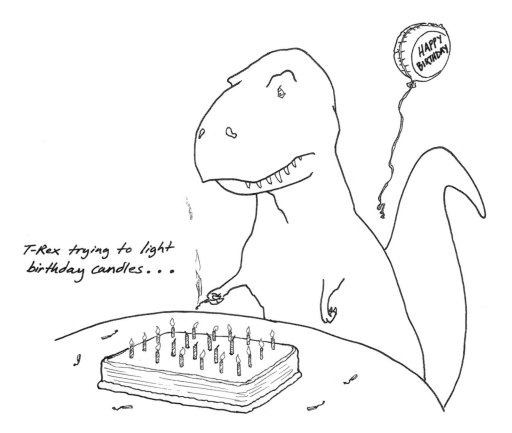

T-Rex trying to light
birthday candles...

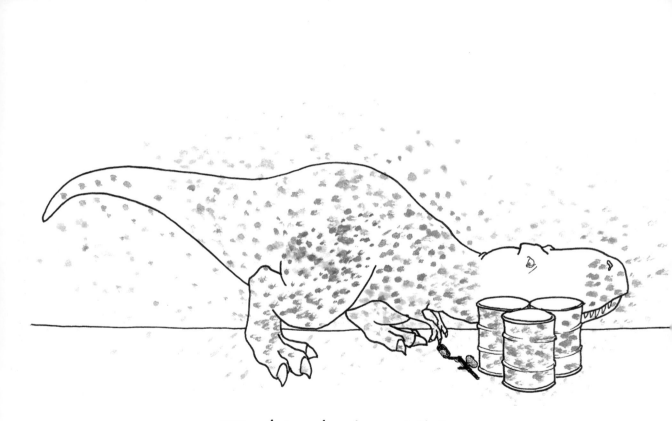

T-Rex trying to play paintball...

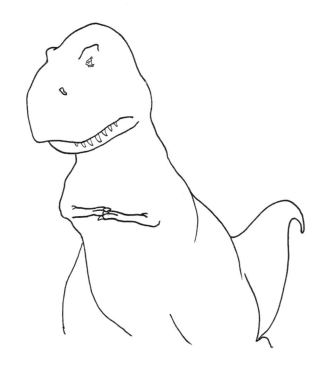

T-Rex trying to cross his arms in discontent...

T-Rex trying to play peek-a-boo...

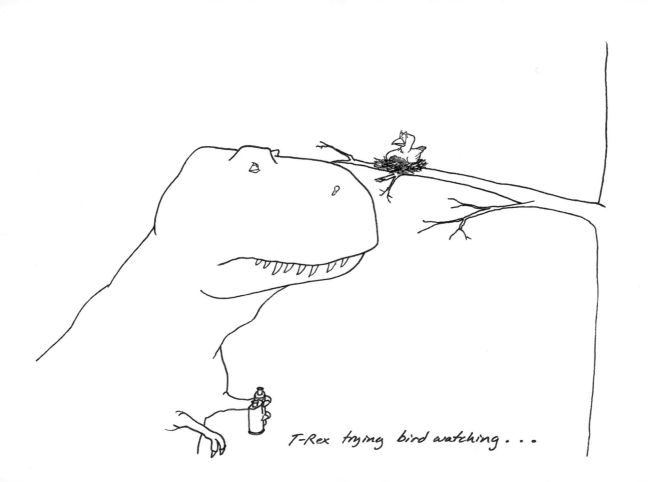

T-Rex trying bird watching...

T-Rex trying to use an umbrella...

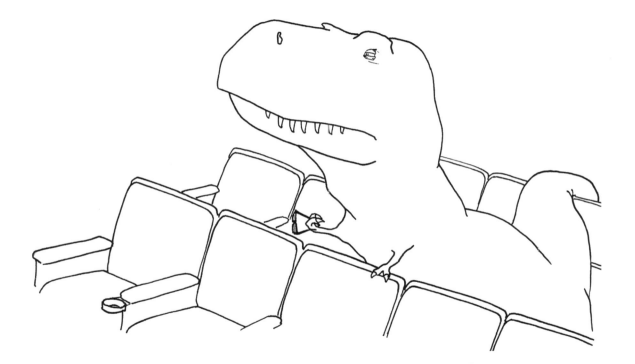

T-Rex trying to watch a movie in 3D . . .

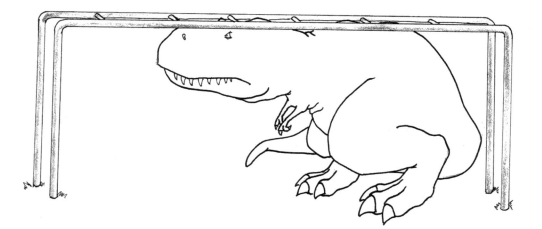

T-Rex trying to climb the monkey bars...

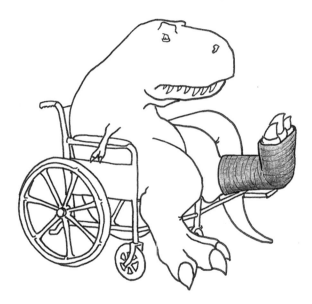

T-Rex trying to use a wheelchair . . .

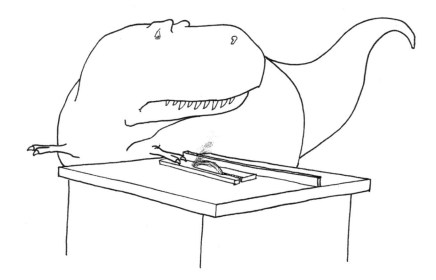

T-Rex trying to use a table saw . . .

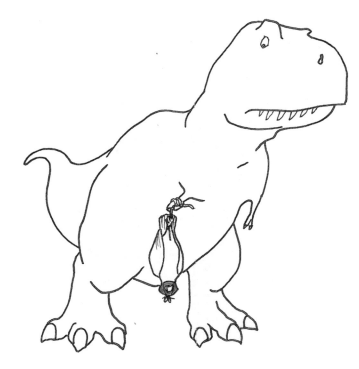

T-Rex trying falconry . . .

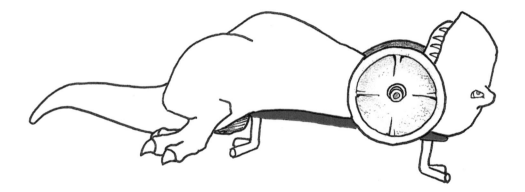

T-Rex trying to bench press . . .

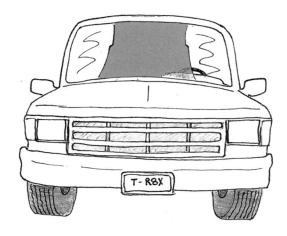
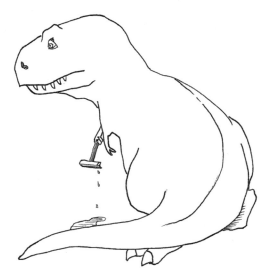

T-Rex trying to squeegee his windshield. . .

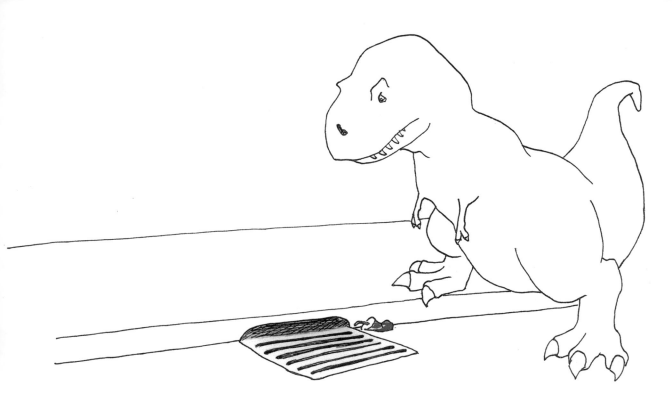

T-Rex trying to retrieve his keys from a storm drain...

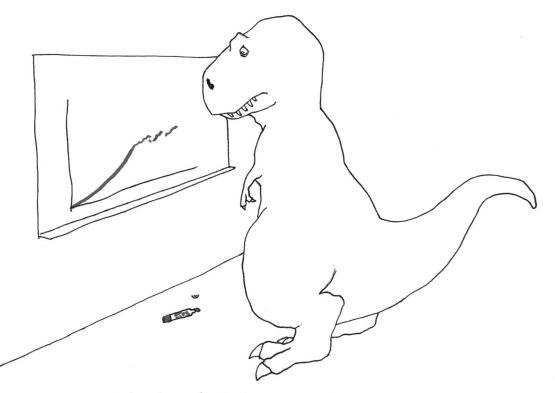

T-Rex trying to chart exponential growth . . .

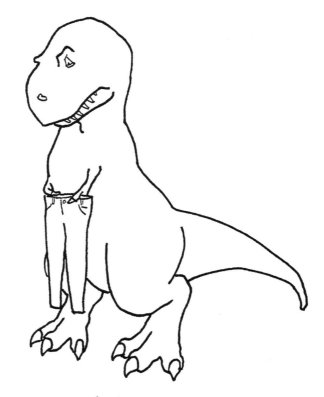

T-Rex trying to buy skinny jeans . . .

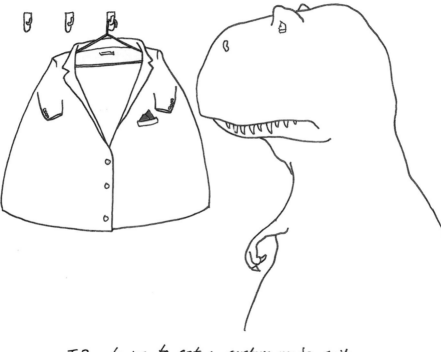

T-Rex trying to get a custom-made suit. . .

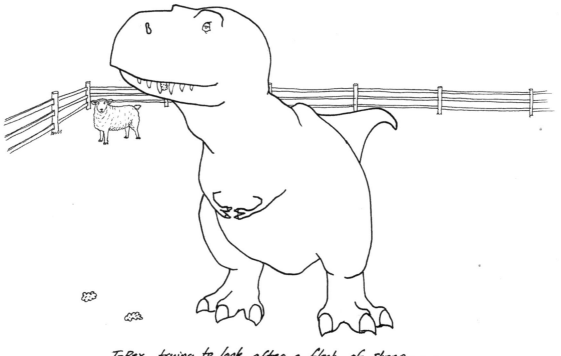

T-Rex trying to look after a flock of sheep . . .

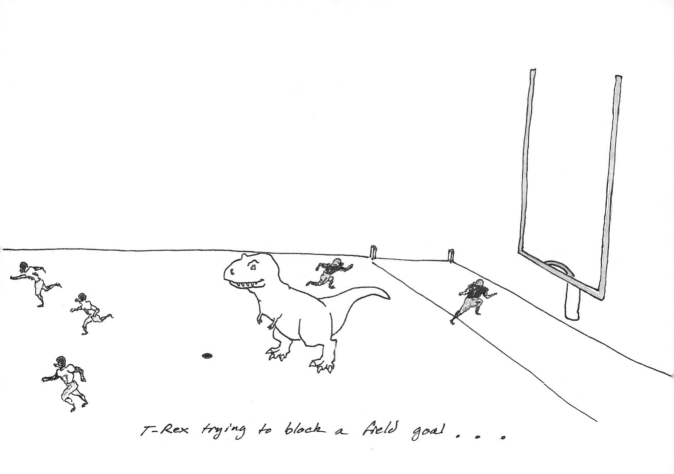

T-Rex trying to block a field goal . . .

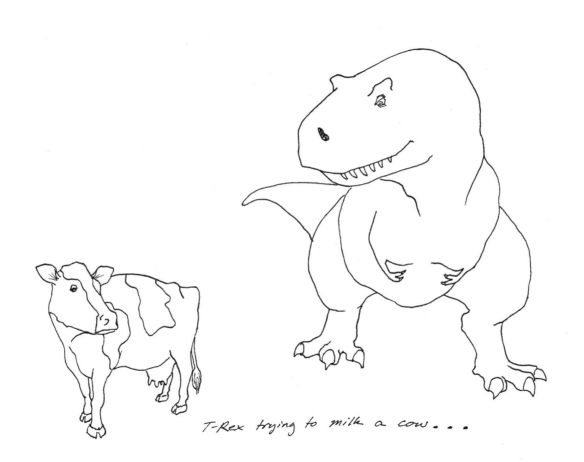

T-Rex trying to milk a cow...

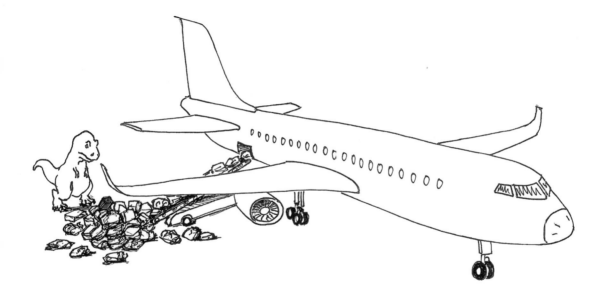

T-Rex trying to work at LAX . . .

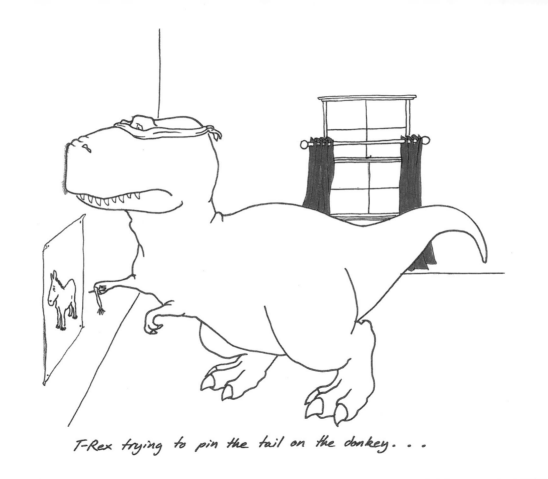

T-Rex trying to pin the tail on the donkey...

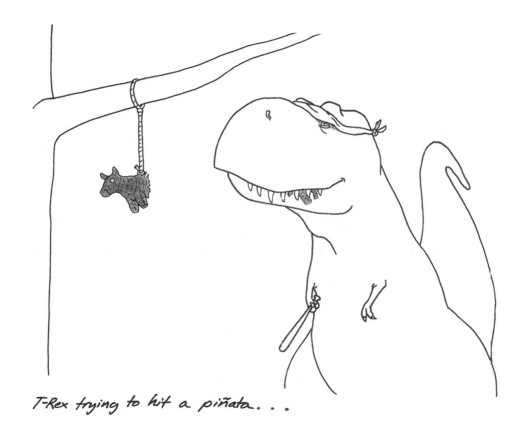

T-Rex trying to hit a piñata...

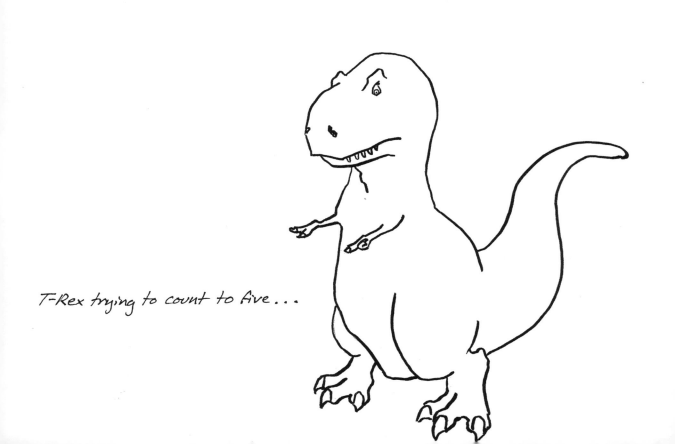

T-Rex trying to count to five...

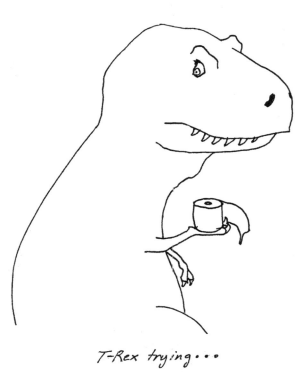

T-Rex trying...

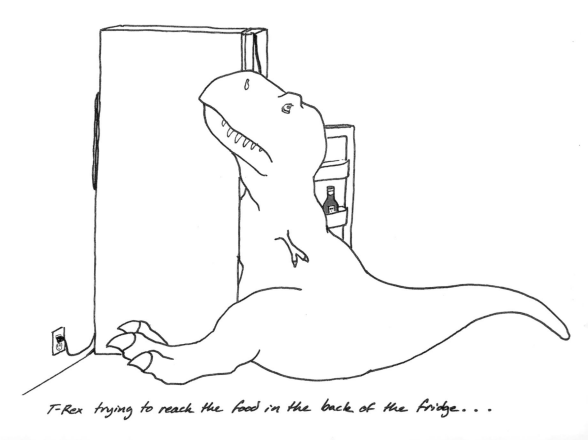

T-Rex trying to reach the food in the back of the fridge...

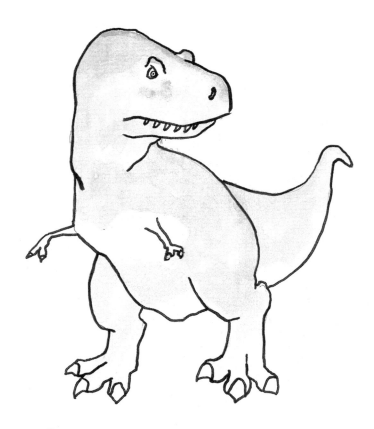

T-Rex trying to use sunscreen...

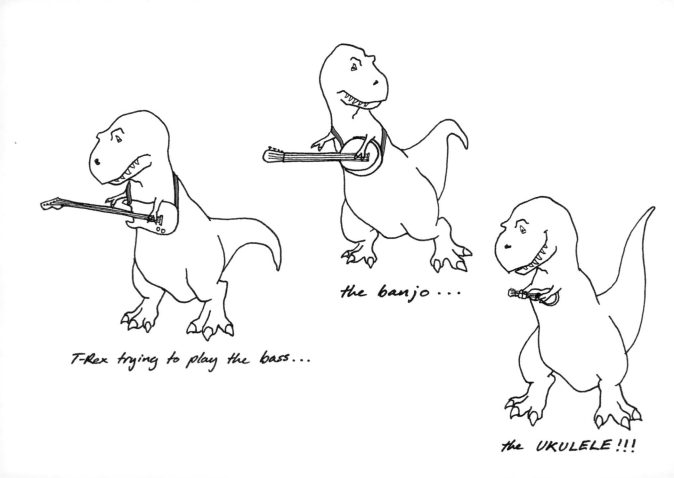

T-Rex trying to play the bass...

the banjo...

the UKULELE!!!

Before its unprecedented popularity as a Tumblr blog, T-Rex Trying began as an inside joke that artist Hugh Murphy shared with his friends and family. When Hugh came up with the idea for his first cartoon, 'T-Rex trying to paint his house . . .', he told his wife: 'Sarah, I have something extremely funny to show you! I can't tell you what it is, but give me five minutes and I'll draw it out for you.'

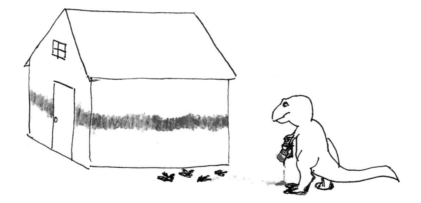

Since that day, millions of people worldwide have enjoyed T-Rex Trying.
http://trextrying.tumblr.com

Hugh Murphy is a student at the University of Southern California Ostrow School of Dentistry.